LET VIRTUE BE YOUR GUIDE

LET VIRTUE BE YOUR GUIDE

FRANCES F. DENNY

RADIUS BOOKS

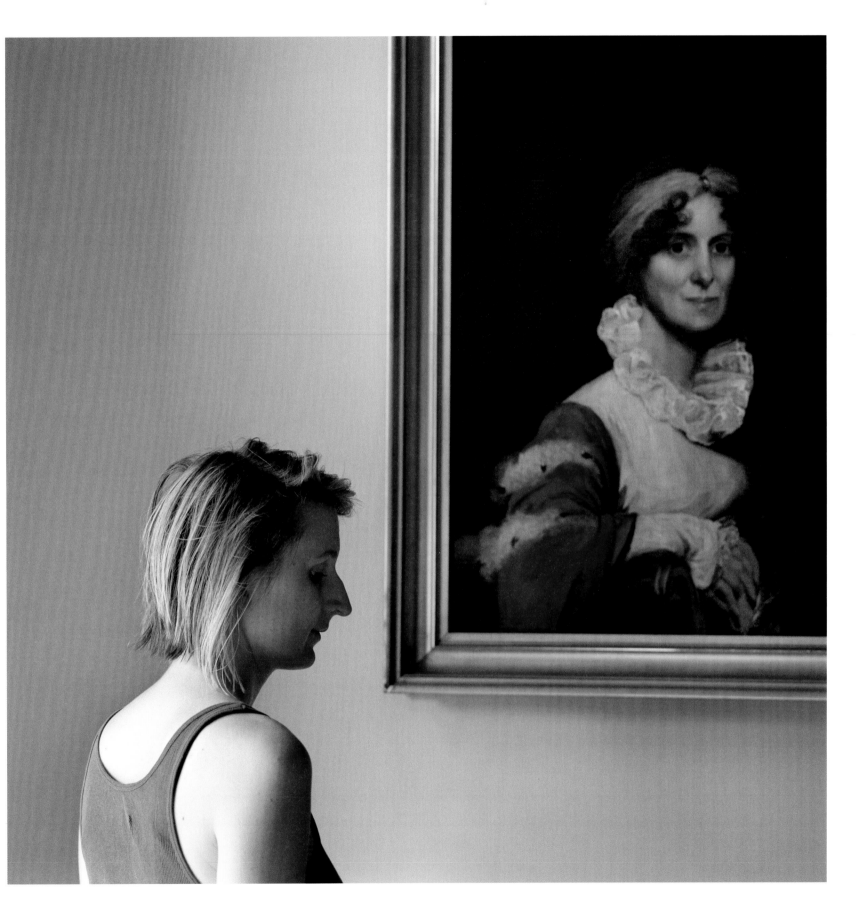

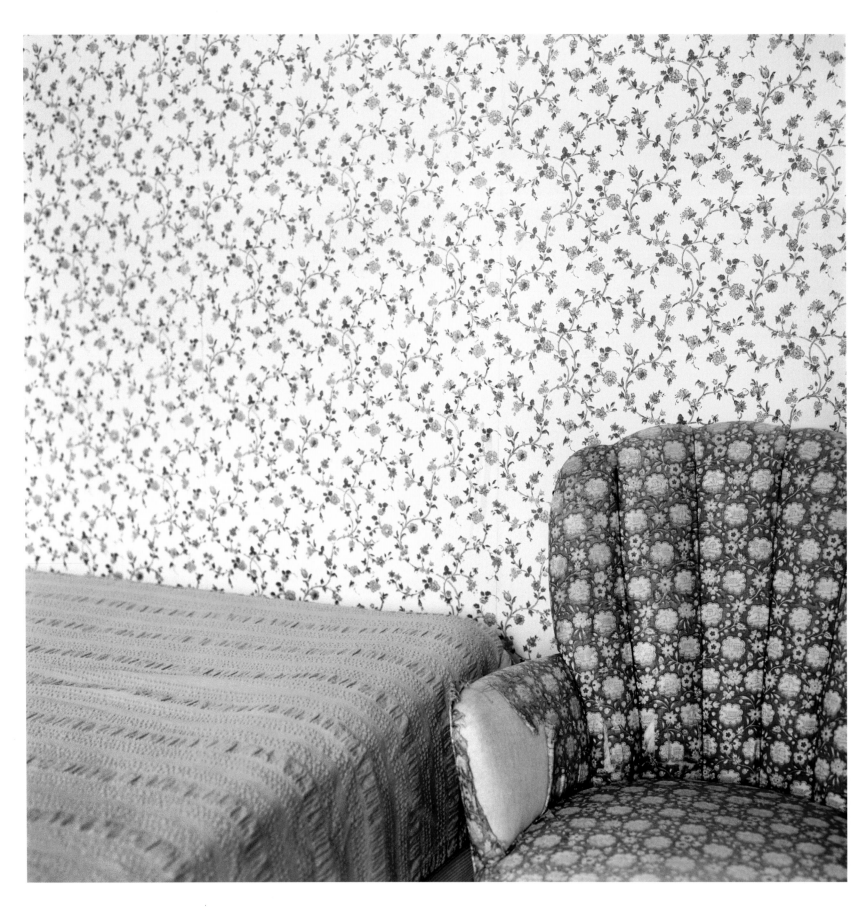

BORN 1948

I would say that much was taught to me by example
and very little was spoken. You just were expected to know.

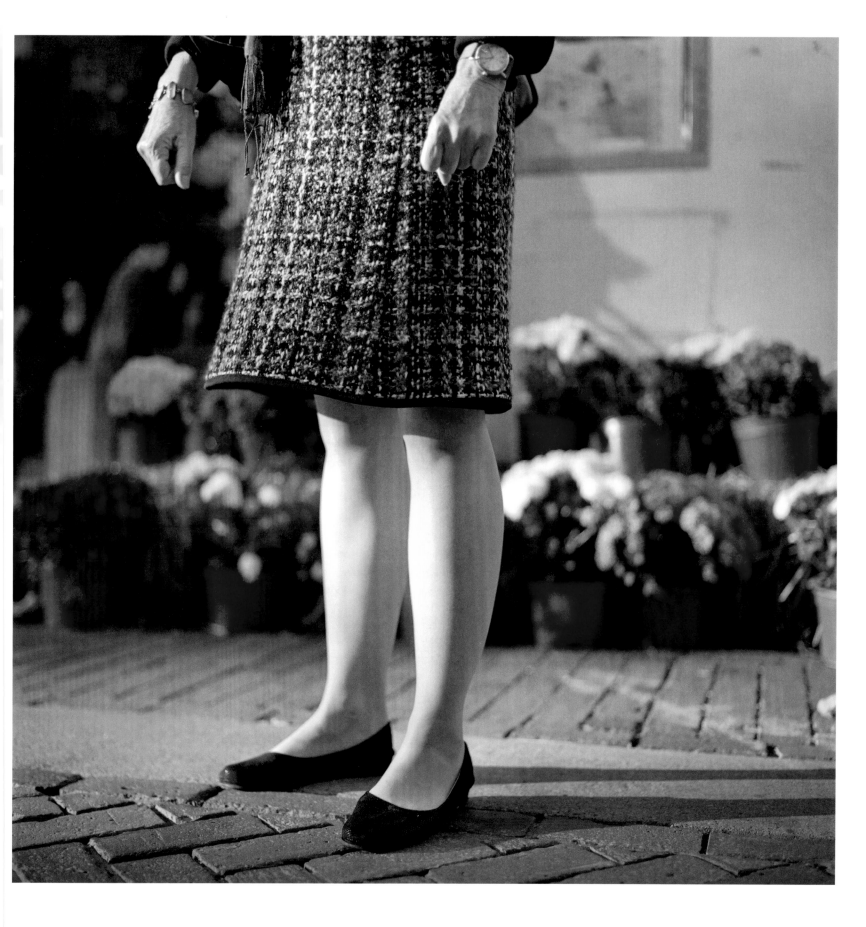

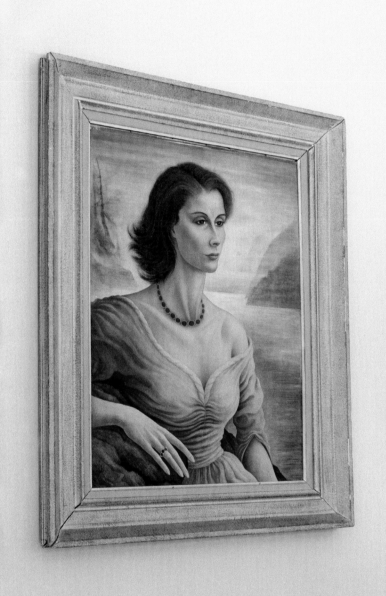

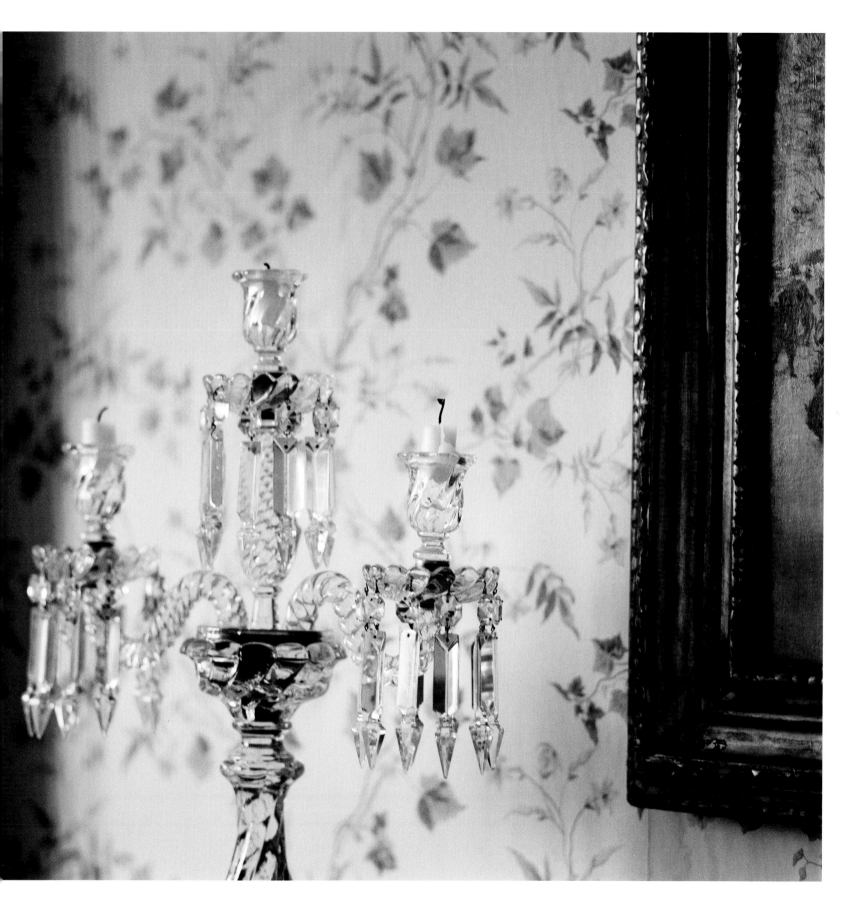

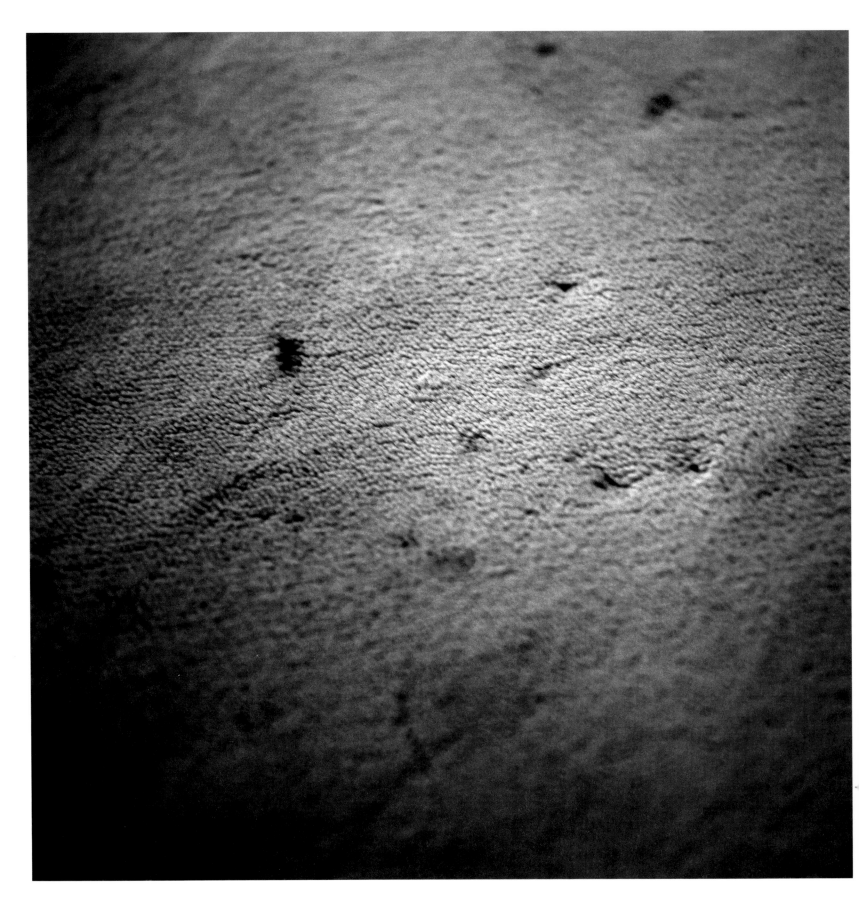

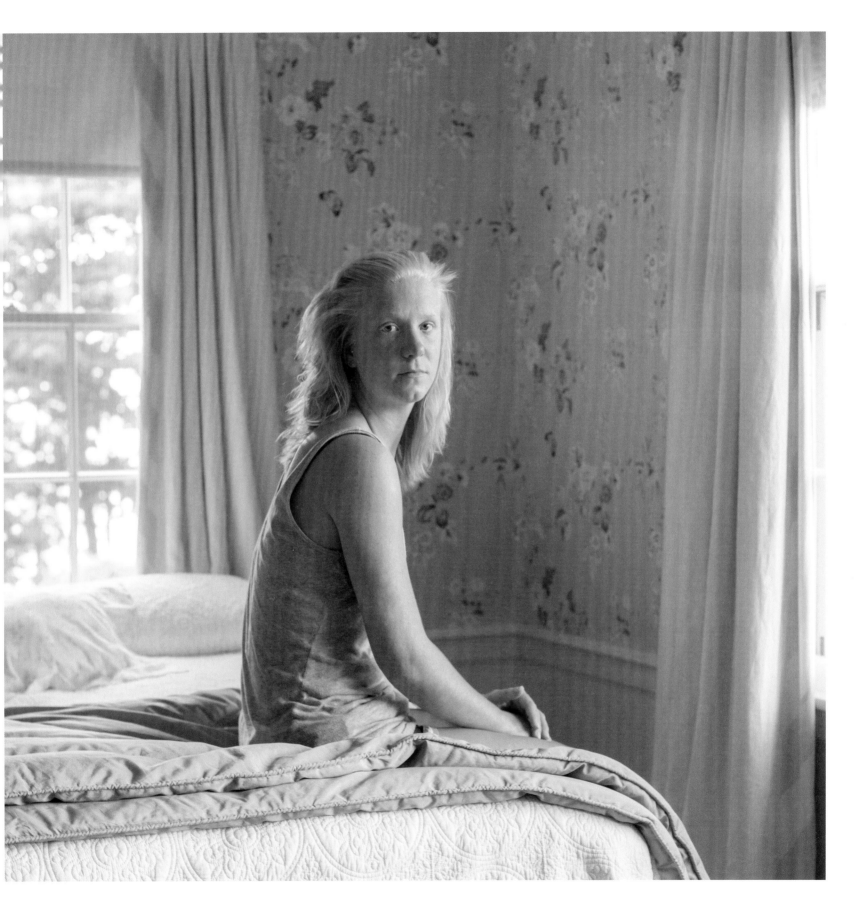

BORN 1945

Advice?
Don't depend on anyone to take care of you—
take care of yourself.

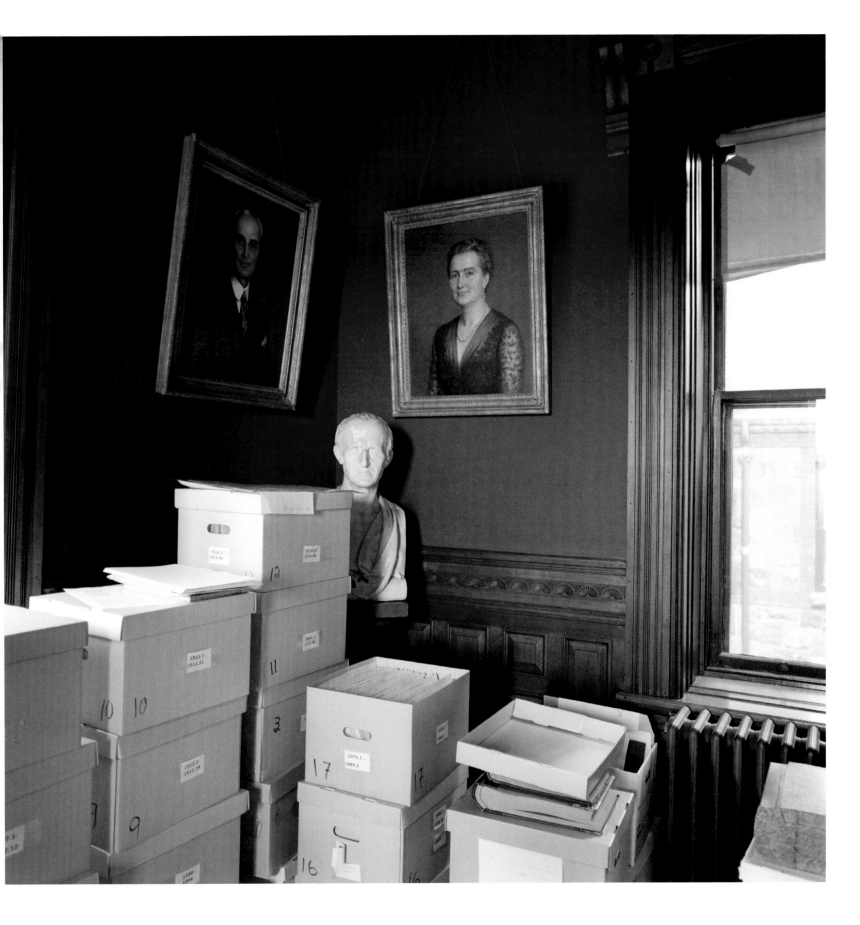

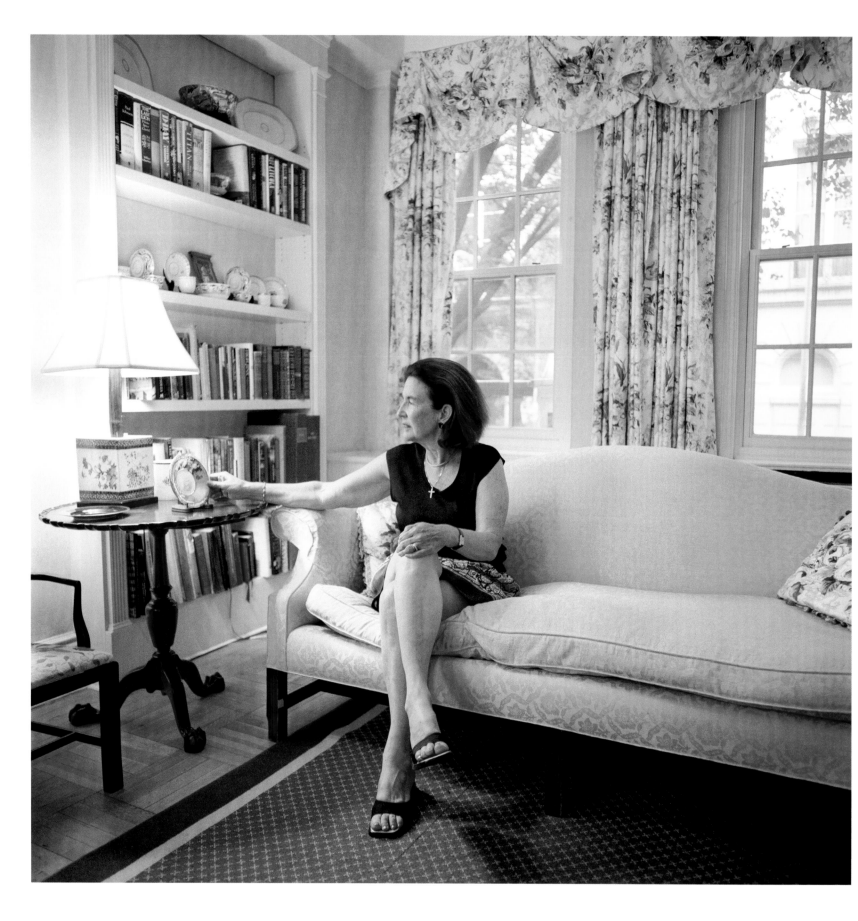

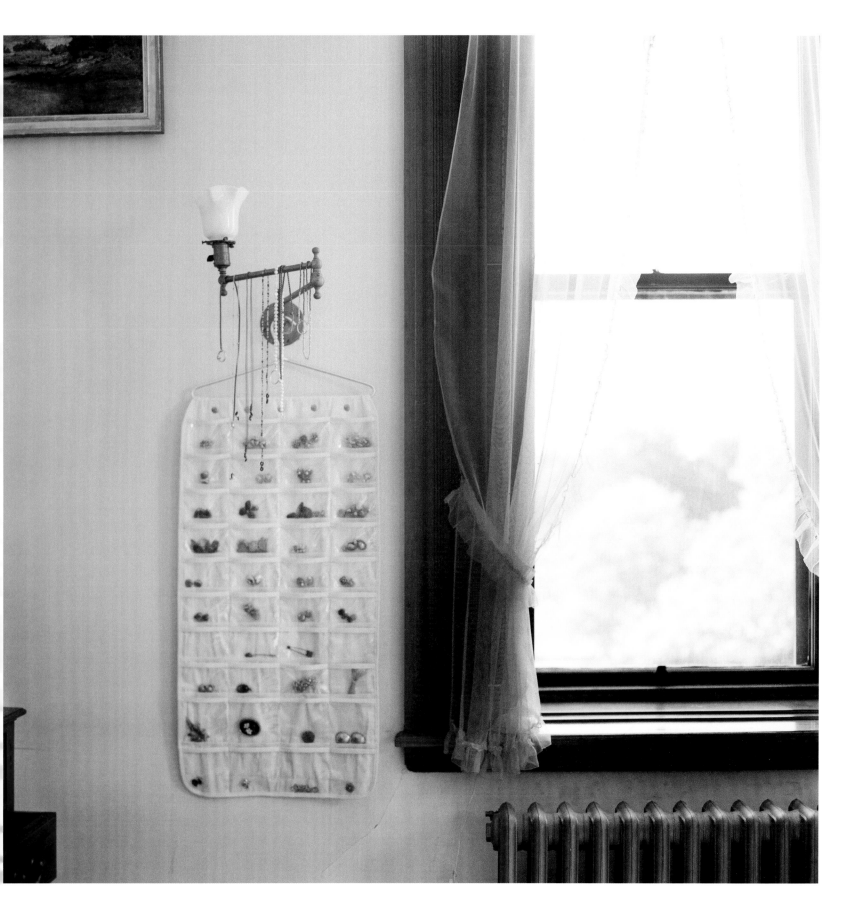

In my family the default was decorum, but with kindness. A good grasp of language and an ability to engage in a conversation about ideas. Attention to personal grooming, with a preference for elegance. Dullness and shrinks were insupportable and topics of conversation would never include medical complaints, sex, money, or news of one's children.

Love was neither demonstrated nor raised except about the arts or an athletic team. A good breakfast was as fit a start to everything as was going quietly to bed if you felt sick; a Band-Aid was enough of a solution to pain, and crying was frowned upon. Bathing regularly was assumed, as was an awareness of current events.

Having a good sense of humor and reading were marks of civility, as was playing adequate tennis and bridge. Friends were inevitably old school chums. Anti-Semitism, racism or snobbery were *not* tolerated. But male chauvinism was unquestioned, as was a prevailing disregard for the lives of children. Boasting about children was frowned upon no matter what they did, and in my family there was relatively little tolerance for being around anyone's children, at least until they were old enough to hold a decent conversation.

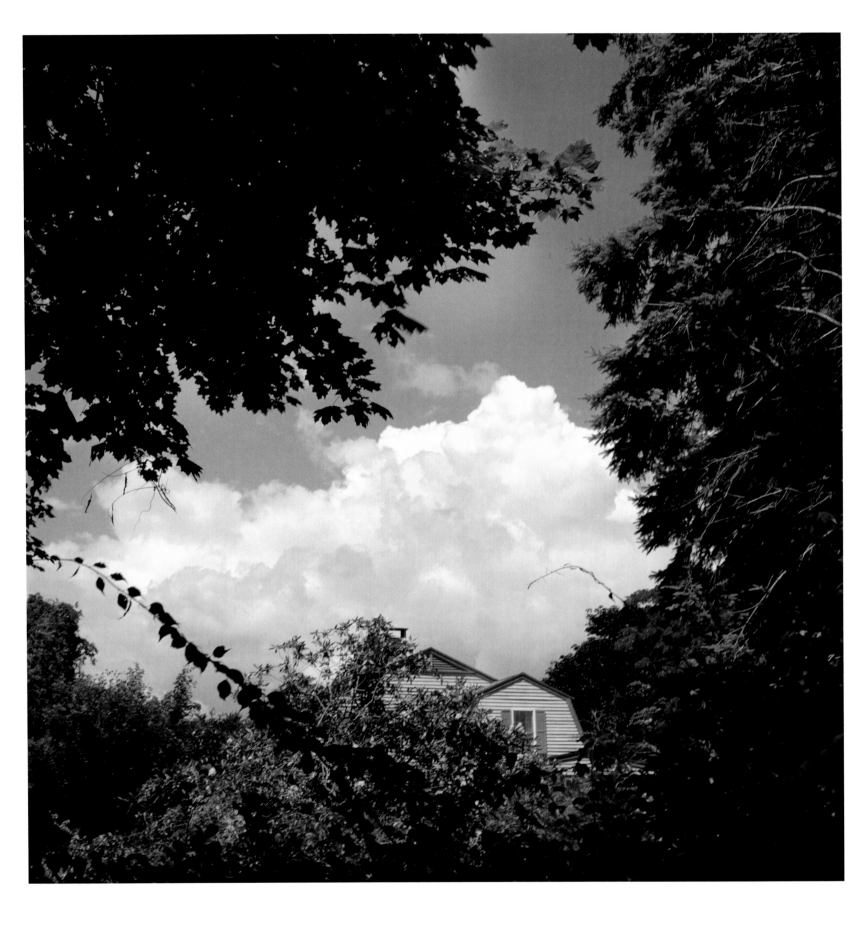

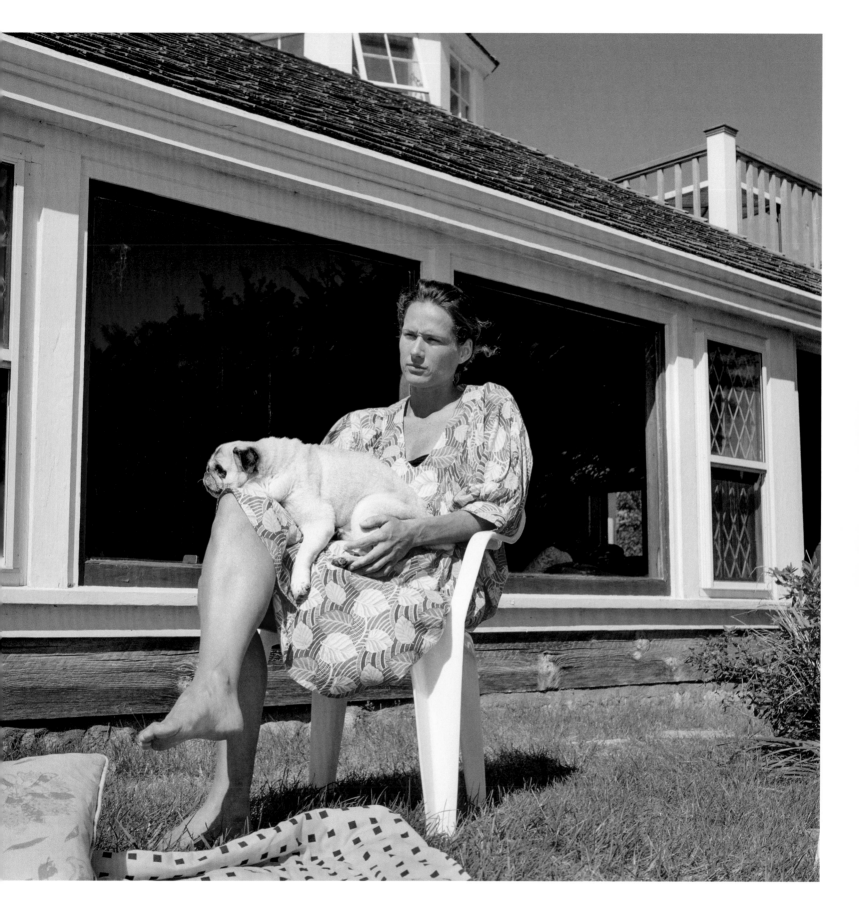

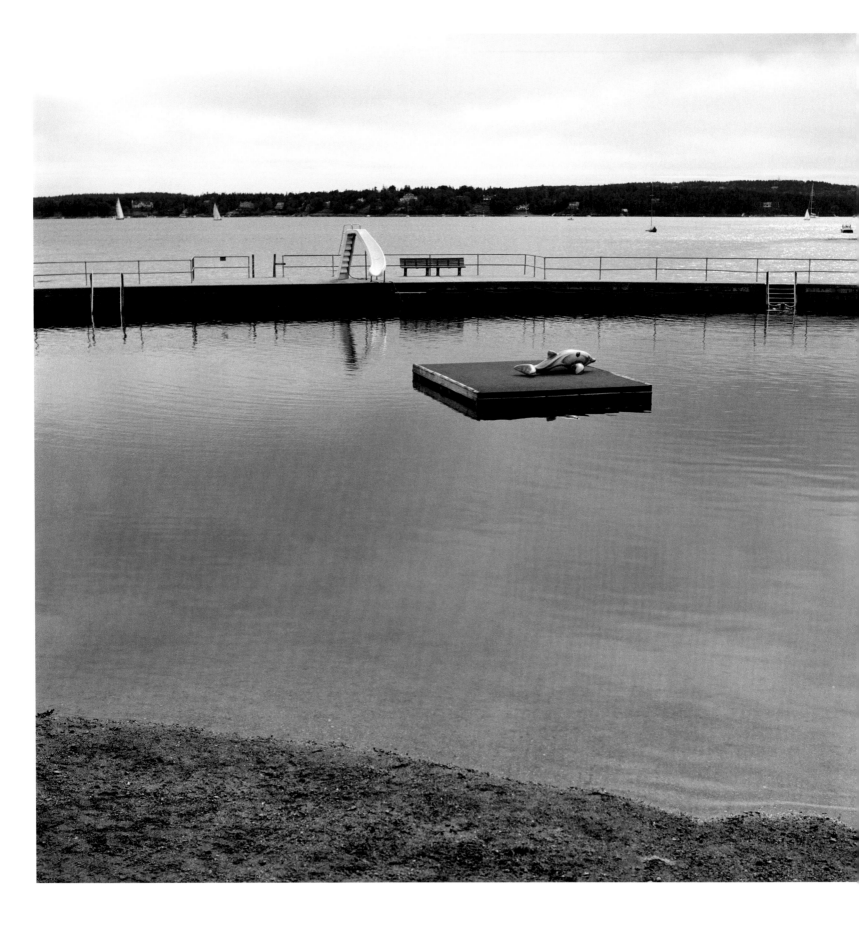

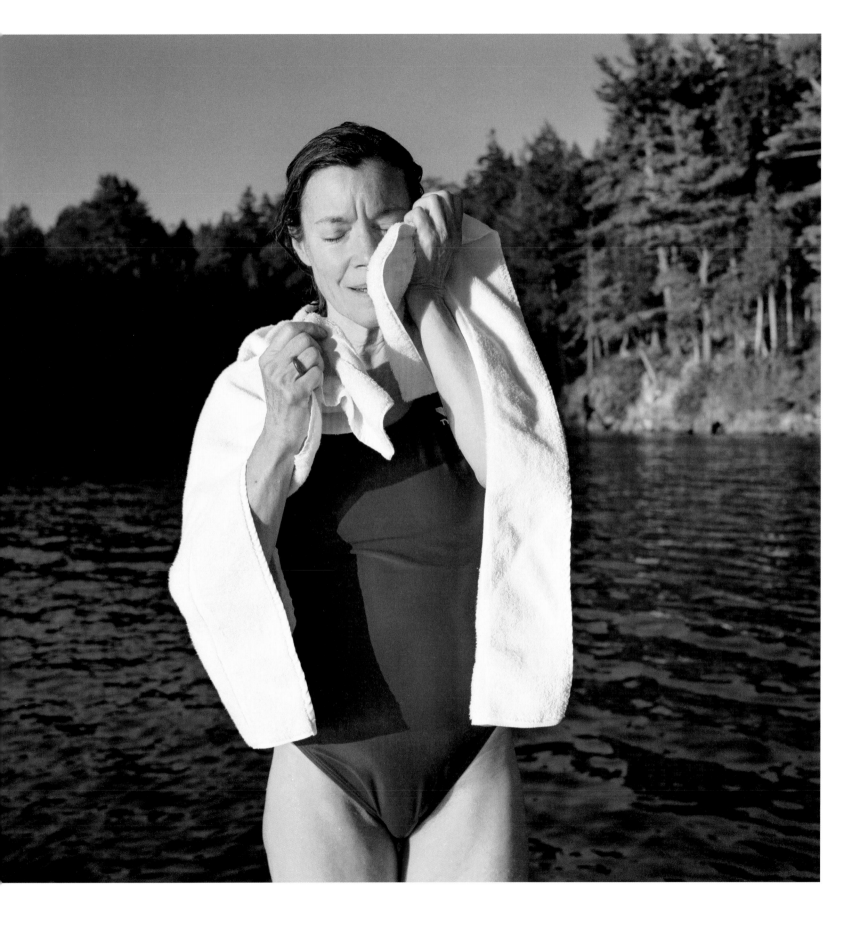

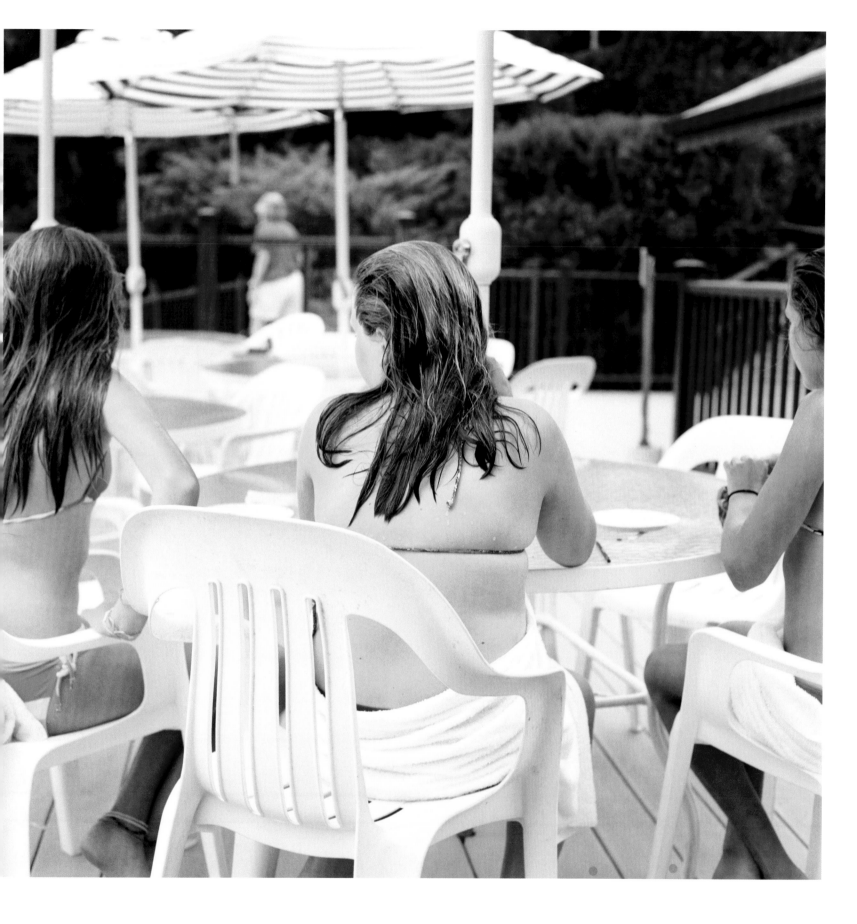

BORN 1944

A lot was unsaid.
I think more up-front talking would have been helpful.

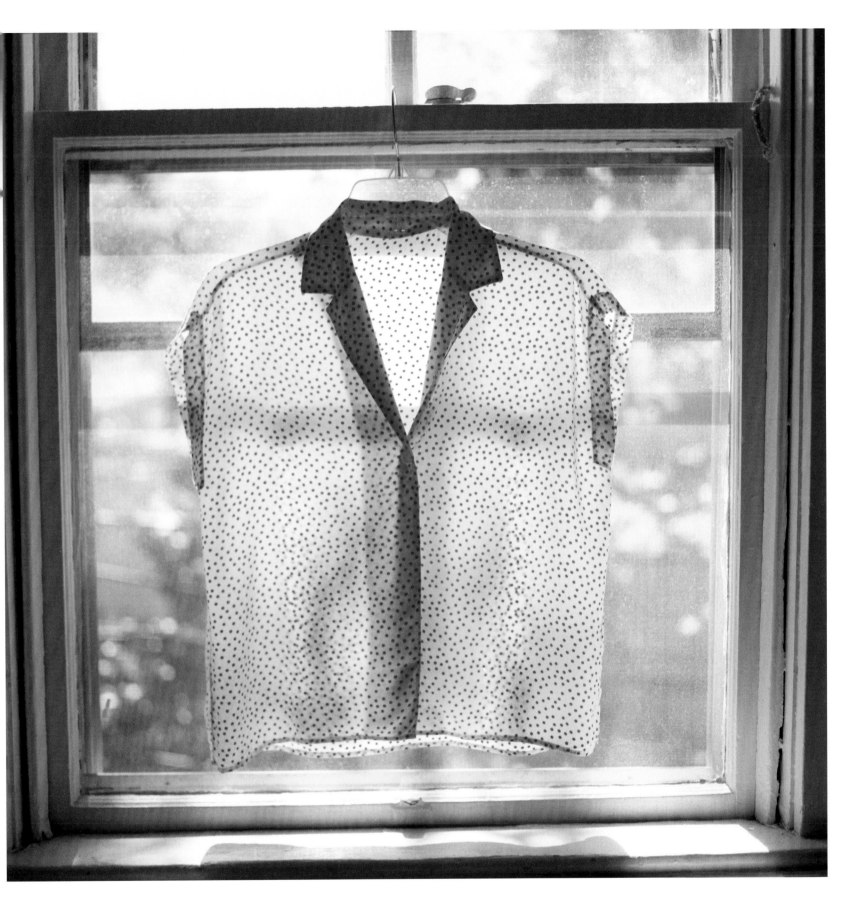

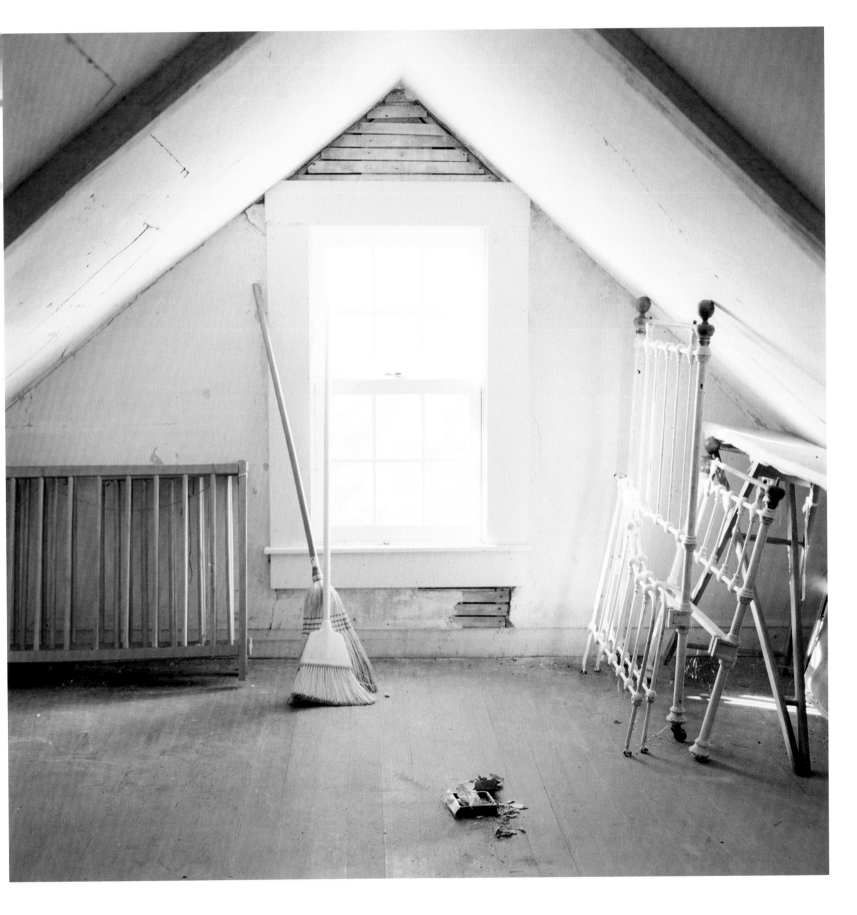

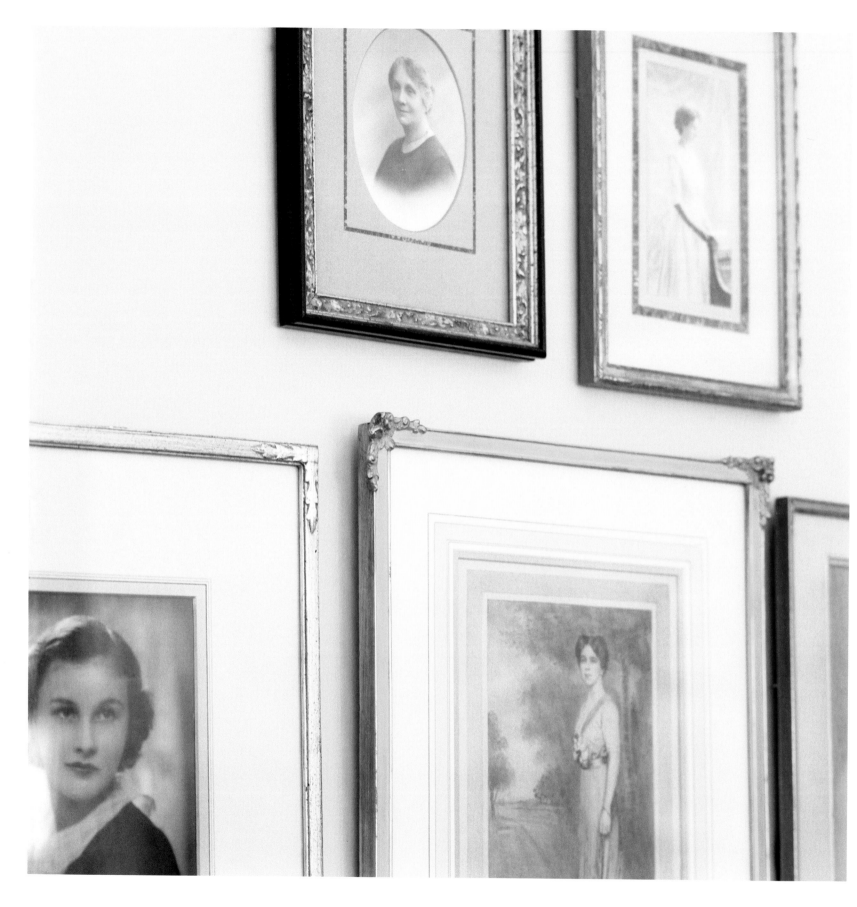

BORN 1984

I've always identified with my WASP identity.
This doesn't mean I'm wearing pearls and married
in a twin set while sitting around a country club.
For me, the sense of connection to place and time
is a part of my character that does define who I am
and who I see myself as.

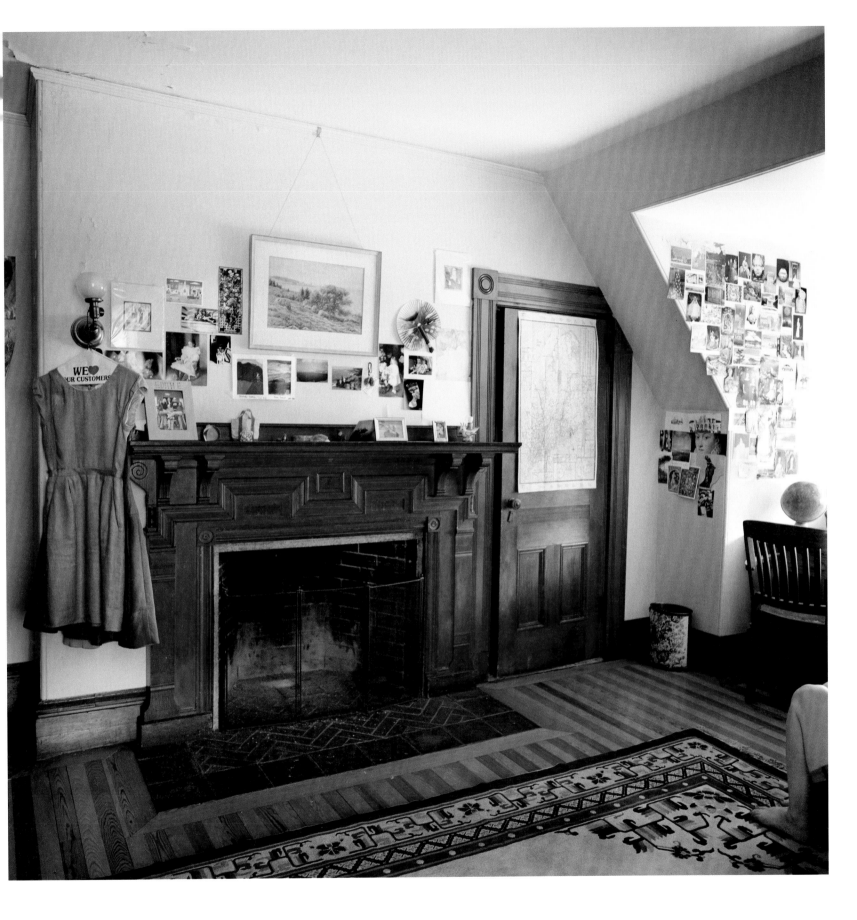

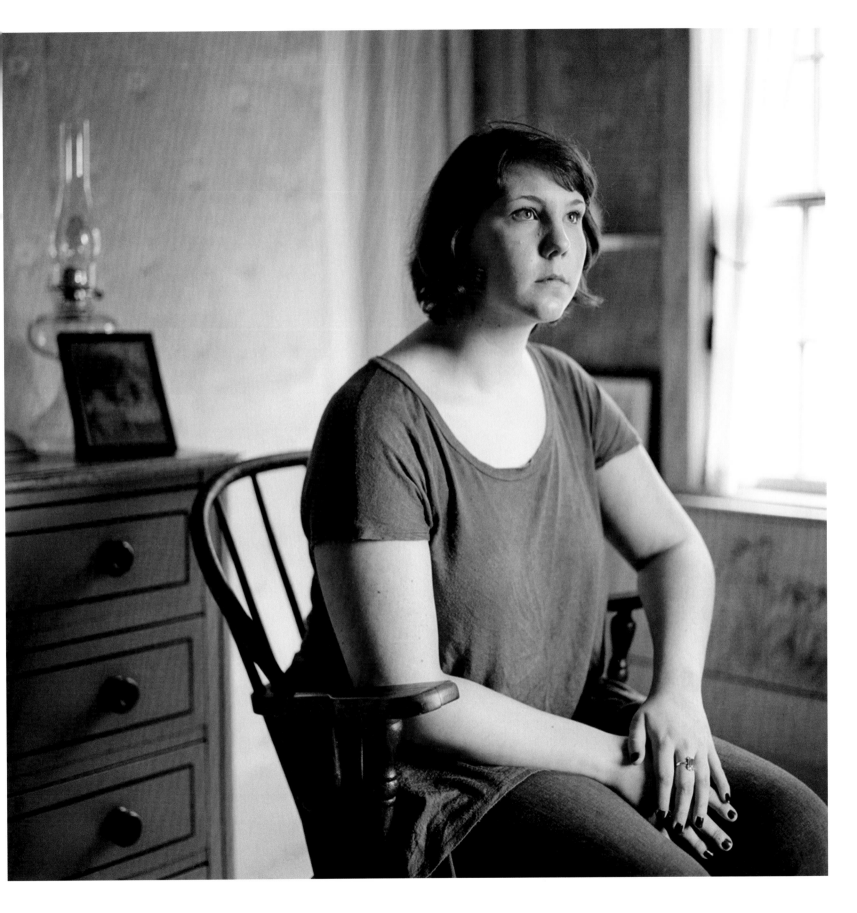

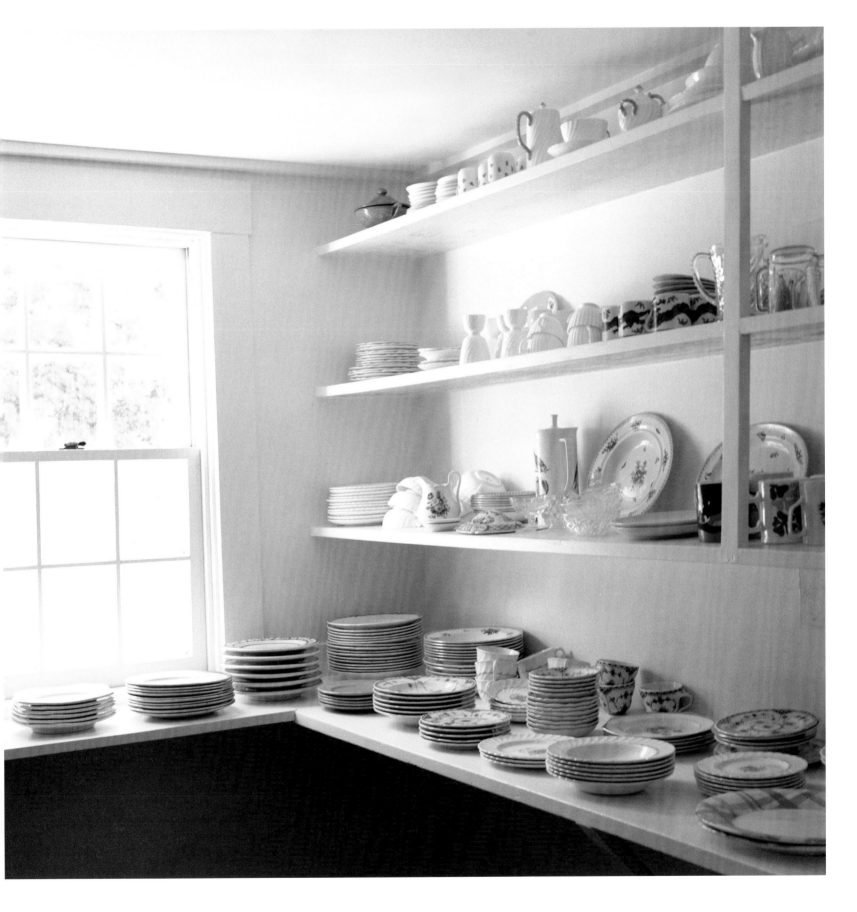

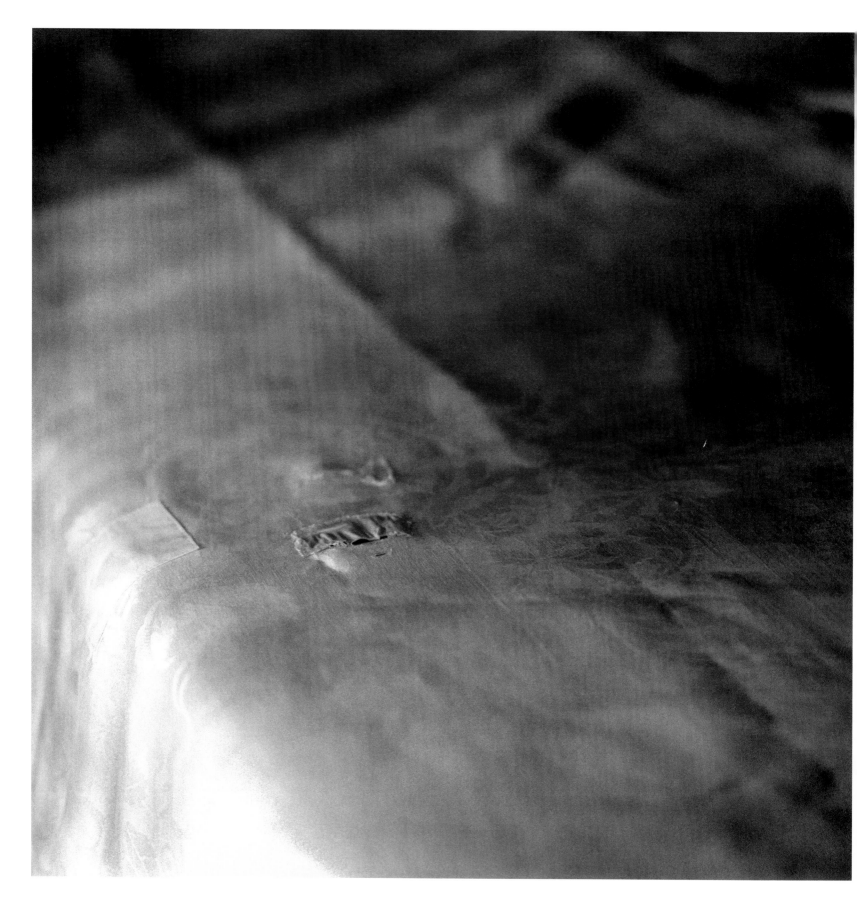

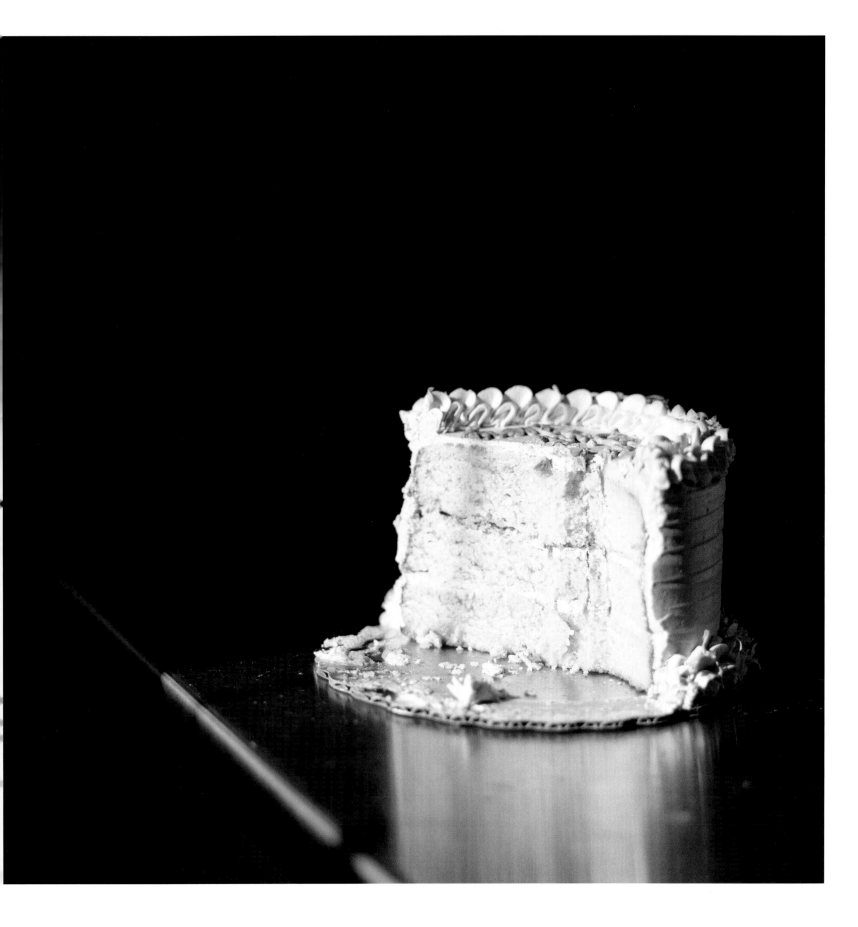

BORN 1974

Be sociable, treat your family politely, and enjoy their company.
Don't talk about yourself too much. Save your money.

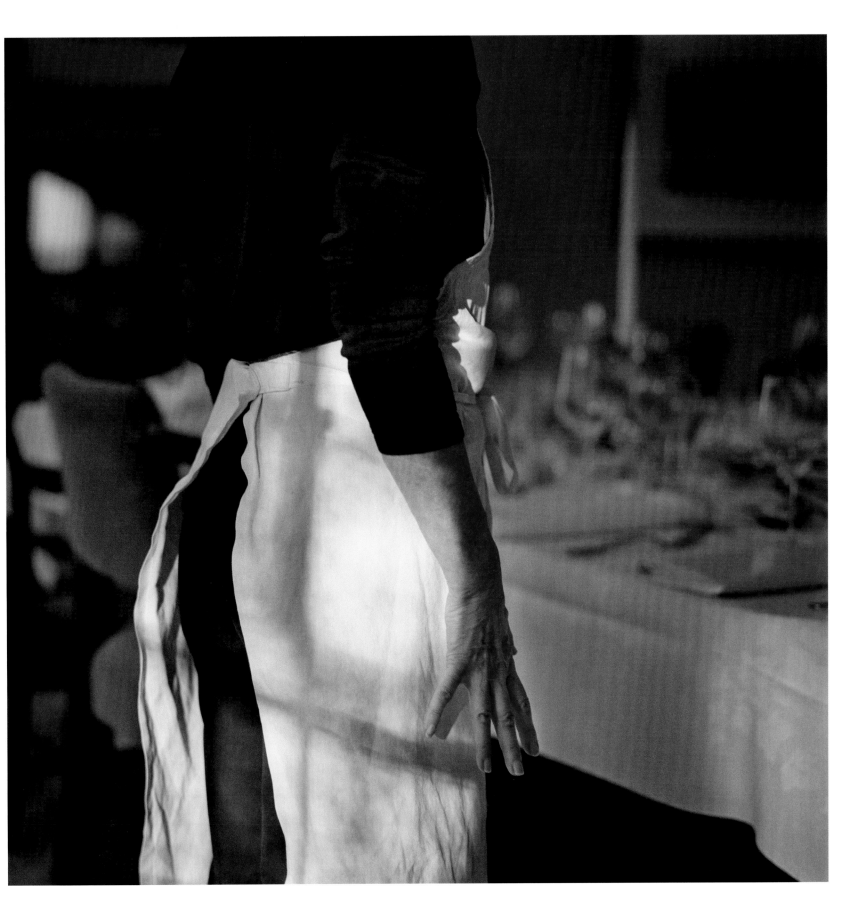

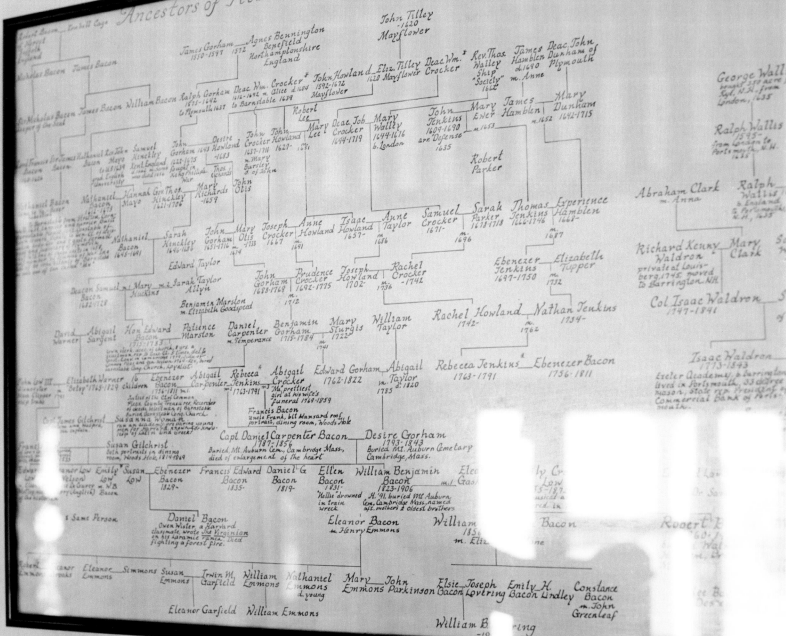

Ancestors of Robert Bacon 1860~1919 and Martha W...

BORN 1970

I had the impression of my parents' simultaneous sense of conflict with, and pride in, their heritage —particularly as the first generation to question it and distance themselves from it (if sometimes only by a half step). I think they were at once happy not to put up with its pressures and entitlements, and nostalgic for its intimacy and privilege.

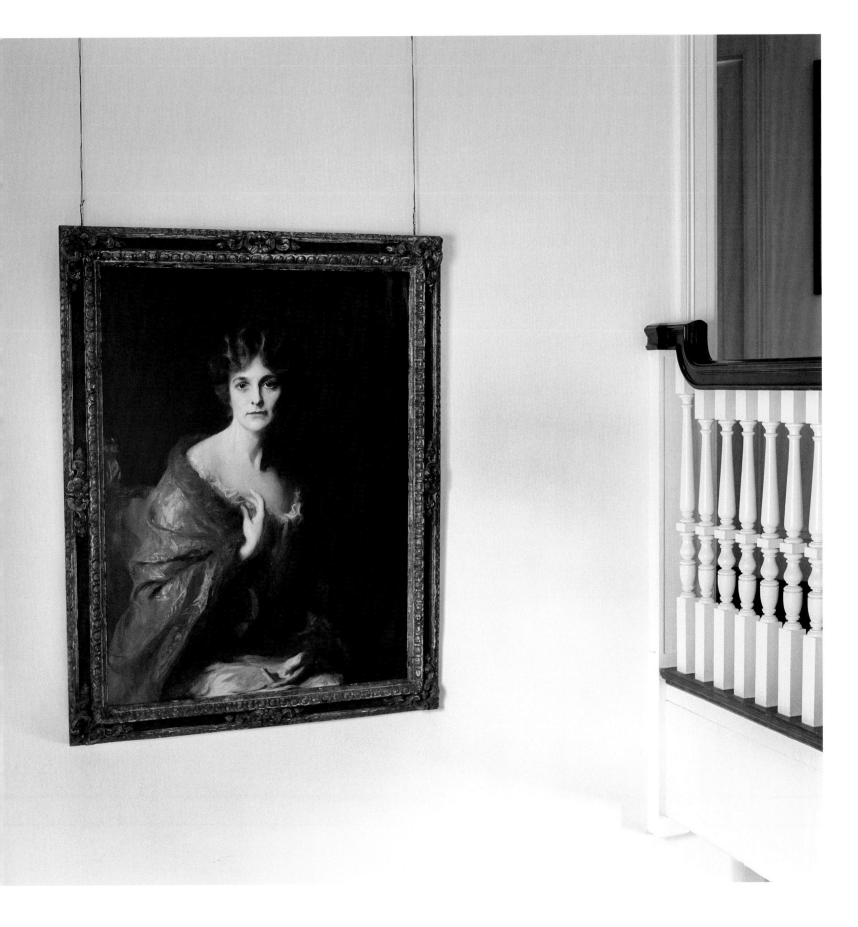

BORN 1945

We were all home for summer vacation, and Mummy was drunk, woozy, and speechless at dinner. She got up to go to her room and collapsed on the floor in the front hall. Dad went after her, pulled her up, and said, "Babs, how could you?" All of us agreed not to talk about Mummy's issues outside the family.

She would always sit in a comfy chair to the left of the fireplace in the living room, and I'd sit on the sofa across the room, talking to her. She was very smart, incredibly well read, very funny, snobby, lazy, entitled, and very interested in me. I adored her, despite all the contradictions and difficulties. Once, I remember her telling me that she had cut her arm, in the inside crease of her elbow, to try to kill herself but that Pa had saved her and sent her back to the hospital. Then, for God knows what reason, she made me come across the room to look at her scar.

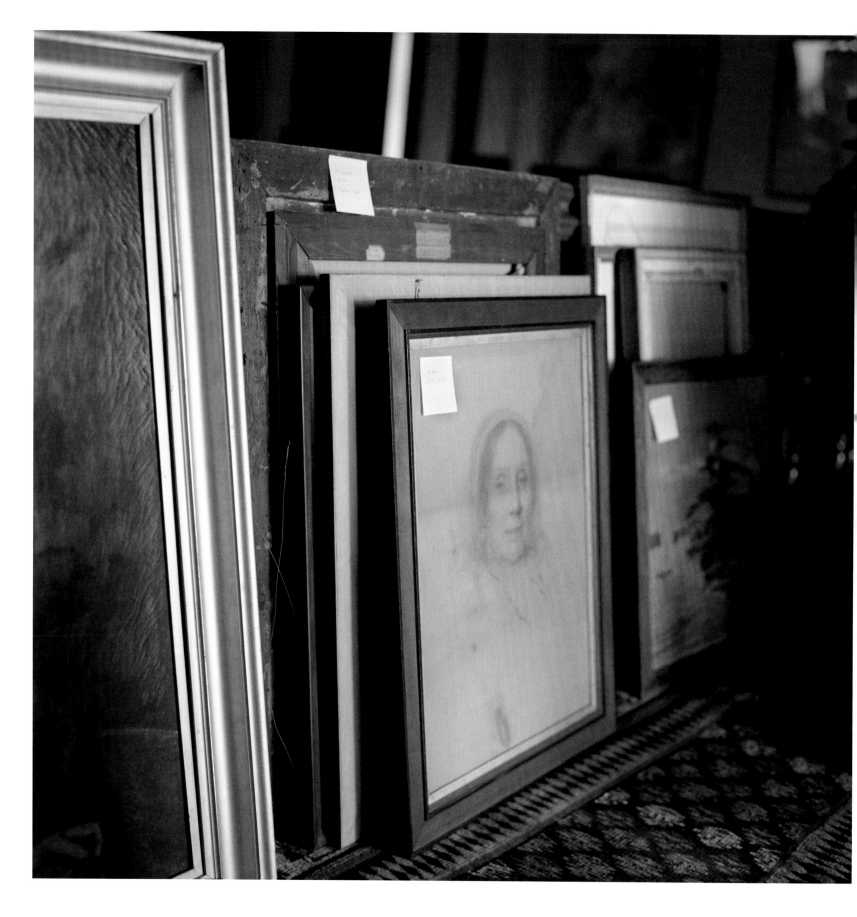

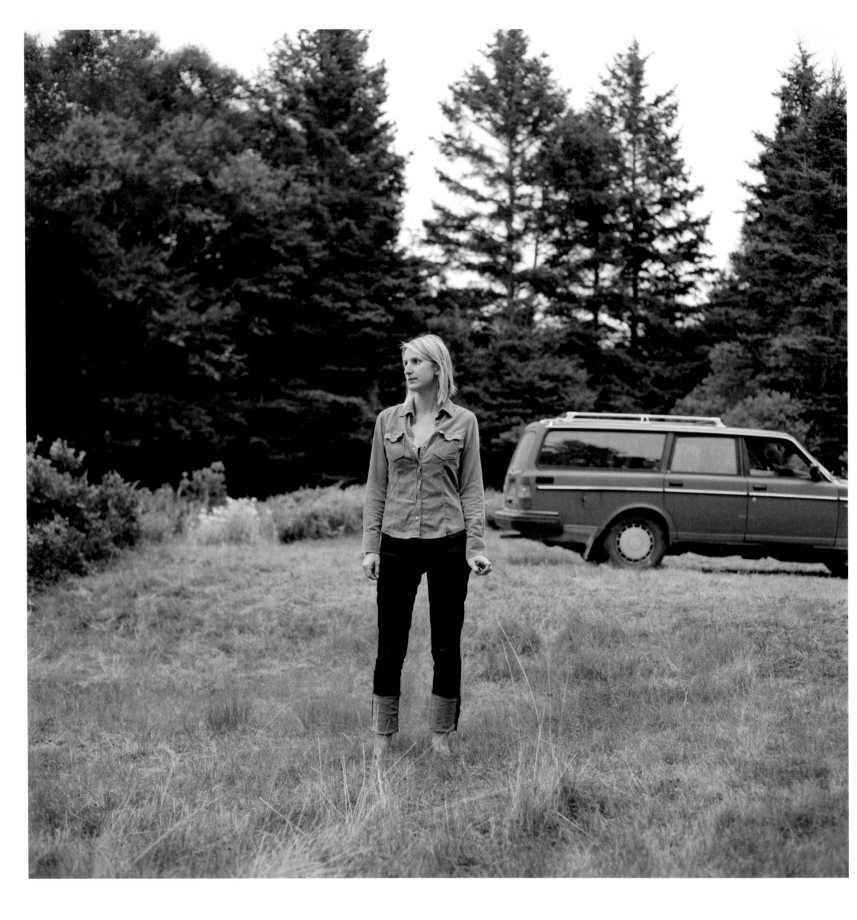

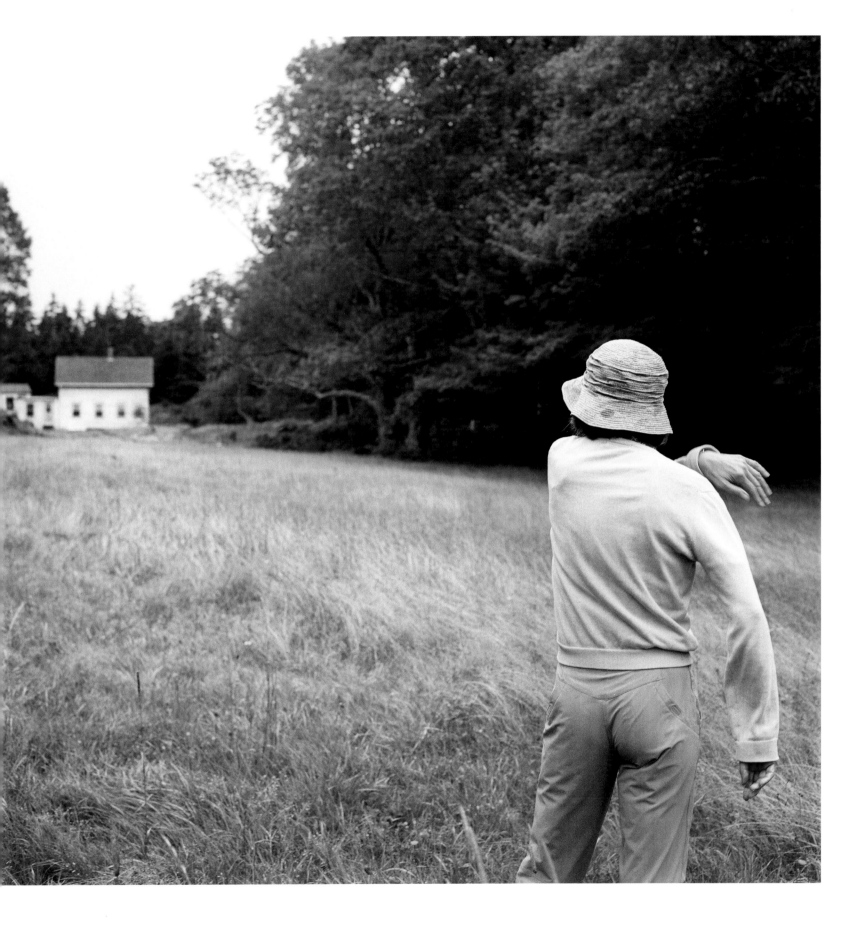

BORN 1979

I didn't really like high school—boarding school.
I really fed off the pressure to perform without having
a very good understanding of what it meant personally to me.

I resisted a lot of it. It was pretty stuffy.

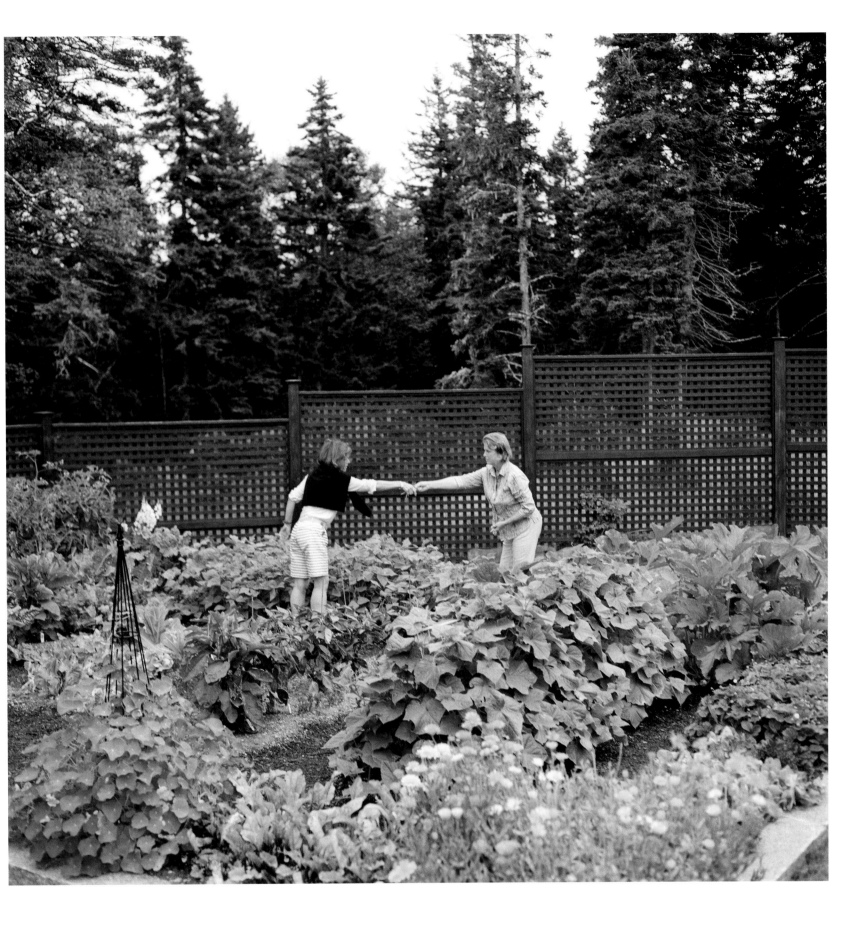

BORN 1974

There is a dark side to identifying with the people who were at the top of the social hierarchy for so long; a lot of other people probably got screwed and our ancestors benefited.

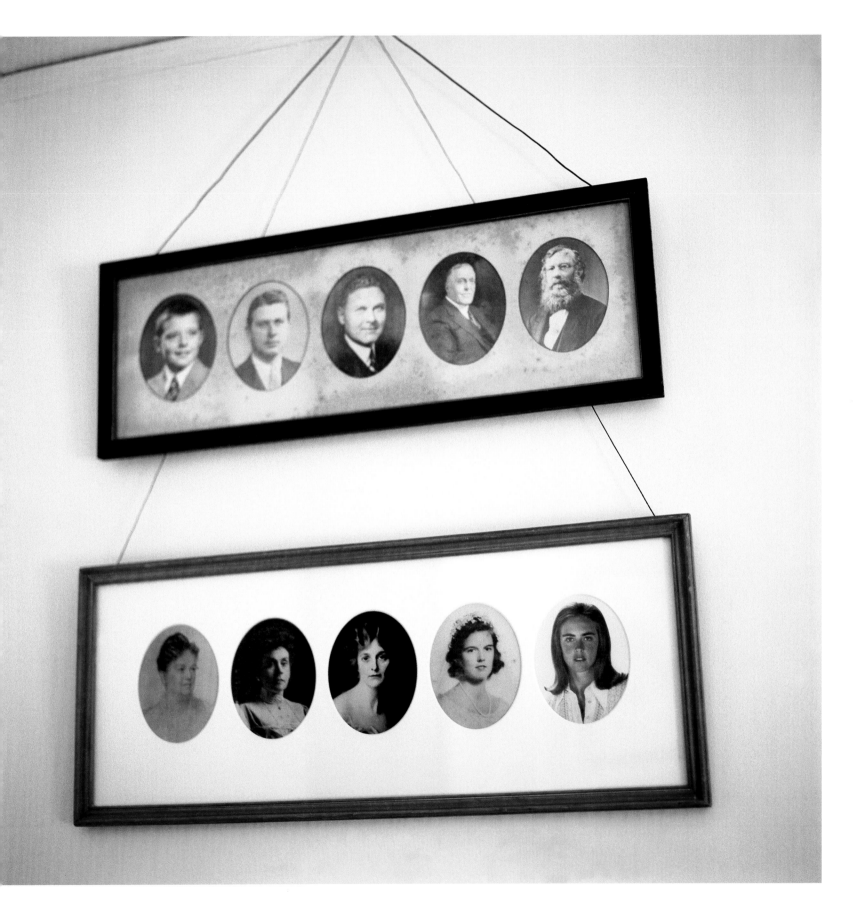

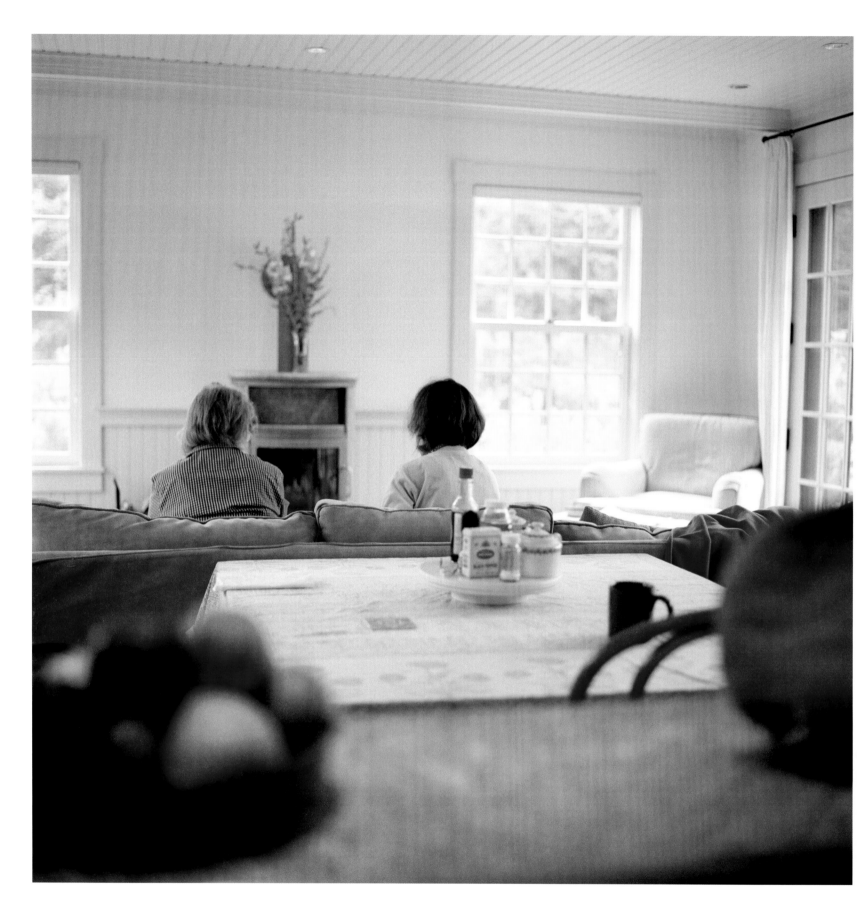

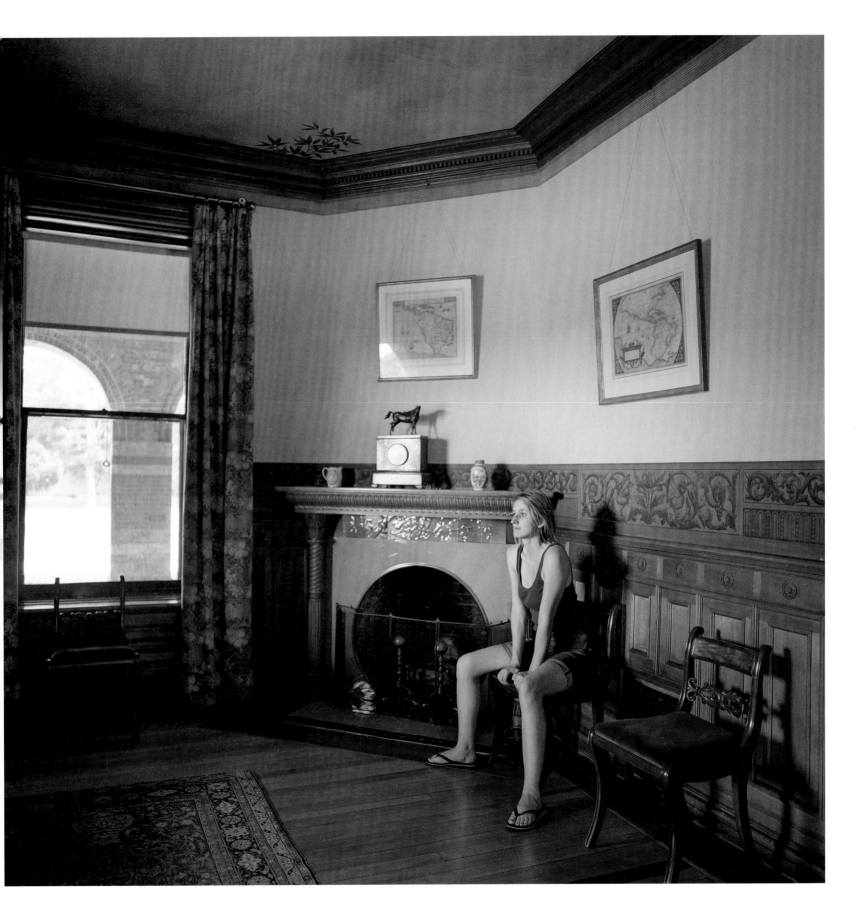

BORN 1944

There were strong implicit expectations. You just
knew what you were supposed to do.

Mostly it was a time of not much questioning.

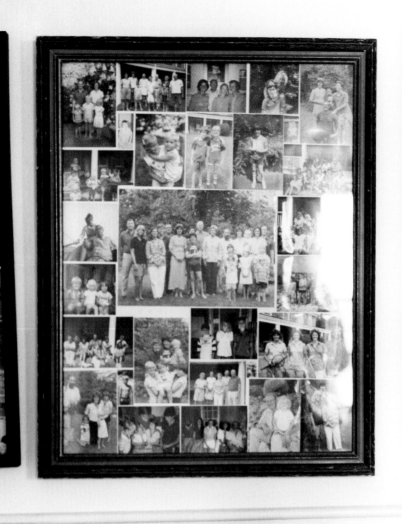
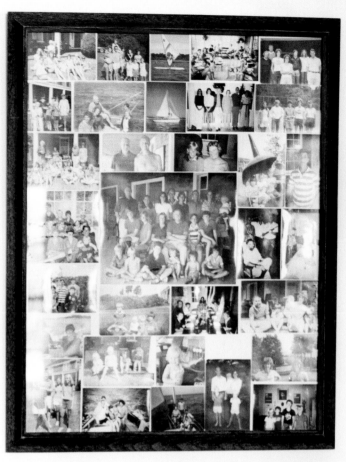
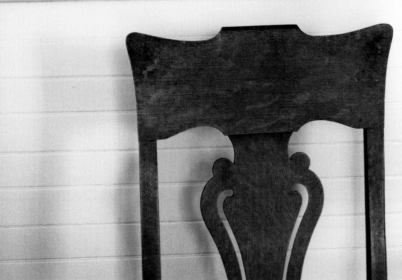

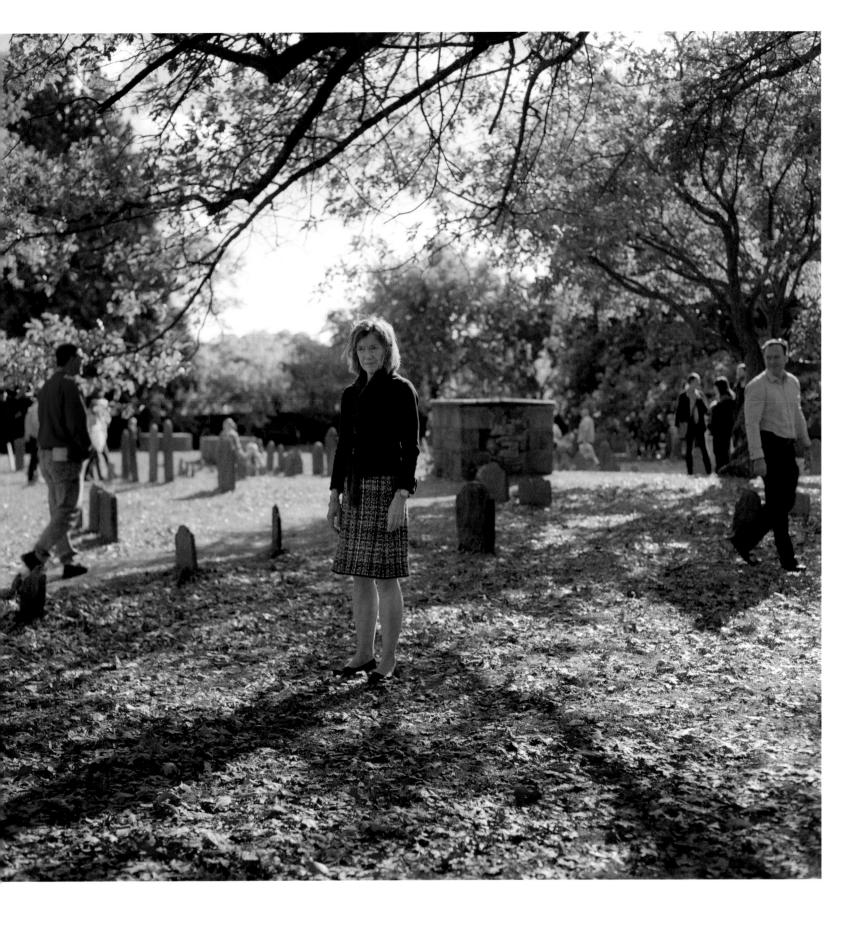

Primer

BY LISA LOCASCIO

What is virtue?
Once upon a time, a valorous and divine effort.
Then it became compulsory moral excellence
for women.

Now the notion of moral authority has slid blessedly
into shadow and virtue finds itself without a scaffold.
What was a yoke becomes a challenge.

Virtue is duty.
Virtue is living alone.
Virtue is not sleeping much.
Virtue is relentless, and kind.
Virtue is relentless kindness.
Virtue is dog-eared precision and blindered drive.
Virtue is hard work.
Virtue does not let go.
Virtue is taking care of yourself.
Virtue is a cross to bear.

Virtue, I have come to believe,
is something one arrives at alone.

FIRST BOOK

1.1

The New England Primer (c. 1687–1690) is utterly
Puritan. Most surviving copies contain the minister
John Cotton's catechism *Spiritual Milk for Boston
Babes in Either England. Drawn out of the Breasts of Both
Testaments for Their Souls Nourishment but May Be of Like
Use to Any Children.*

1.2

Cotton arrived in the Massachusetts Bay Colony in
1633 and died there twenty years later. His grandson
Cotton Mather engineered the Salem Witch Trials
as right action against Satan's attempted coup over
New England.

1.3

I went as my witch-self the Halloween I was eleven,
wearing a long, curly red wig, red cloak, and straw
broom. I rode out to Salem 319 years after the trials.
It was trash stores and ugly buildings. Only in the Witch
House, the only extant structure with a direct link to
the Trials, did I feel the beating of those black wings.

1.4

The female children of New England learned words
and virtues by sewing needlework samplers. A marking
sampler taught basic embroidery, the alphabet, and
numbers. Later came the pictorial sampler, a prettily
embroidered picture that modeled the goodness of
its maker and her family for men who might want to
marry her.

1.5

My own little-girl bedroom was walled with a print of tiny pink flowers on off-white, which I liked, but slowly covered with lurid photographs I liked better.

1.6

Whenever I see two patterns juxtaposed, I think, only one motif can win. Will it be the chair whose arm has already shed a rectangle of dingy blossom print, or the rosy bedspread, or the wall bigger than both of them, where flowering vines grow undying?

1.7

Did those dame school girls stitch the words of *Spiritual Milk for Boston Babes*? The Puritans believed God could and would strike down a child for defying his will. What I believe is that Satan succeeded in his coup, and I am glad.

2.1

Images of the dead are always peeking over the shoulders of the living, a membranous vale stitched together by story. How to pick whom to see, to whom to listen?

2.2

In my family's possession is a portrait of my father, his sister, and their mother seated on a purple velvet settee. The painting is large, perhaps five feet across, and once hung above the plastic-encased white and gold brocaded sofa in my grandmother's parlor, across the room from the never-used silver coffee service. Beside it stood a crystal candelabrum. This grandmother was born into the first American generation of her family, and her home was a museum of exerted aesthetics. She wears her New Look day dress in our basement now. My father has never hung the portrait, I think because he cannot bear it.

2.3

Try to decode the logic of the rows of faces and you come up short every time. If the men atop can be made to make sense as a gradient of age, their place in history is utterly lost. And if the women below form a timeline, a half-game of temporal Red Rover, their stricken, lovely faces sing a different song. That I call them lovely is part of the problem.

2.4

There are, somewhere, painted portraits of my mother and her mother, too, but I'm not sure where. In our house. A recurrent theme in embroidery samplers is the commemoration of the dead, and the maker's acceptance of her own eventual demise—marrying virtues. When I find my grandmother's portrait in the basement, or my great-grandmother in her bridal veil on the wall in the kitchen above the clock my grandfather gave us, I wonder how I measure.

2.5

Some years ago I found a website run by a woman who called herself Quaker Jane, which proffered tips for living Plain, which Jane did, with a wide-brimmed relish. My favorite part of her site were photographs of her gardening with her small daughter in cape dresses and broad sunbonnets.

2.6

One day Quaker Jane posted an announcement: "I am writing to inform all that I have set aside wearing plain dress. I feel the Lord is guiding me to do so, and so I cannot continue. I feel a bit like I am being fired, not as a punishment, but as a Requirement for his own reasons. It isn't about me."

2.7

The appeal of a portrait is that it *is* about you. Explaining the concept of past lives, my mother told me that she had once visited an estate where every pair of painted eyes followed her. By the time she left, she was sure she had once been one of them.

2.8

Occasionally Quaker Jane reappears, going now by a nickname, Ibbie. She directs me to purveyors of modest cape dresses and advises correspondents in head-covering. She shows me a picture of her daughter. I see a sampler: Ibbie and her daughter stitched in hot sun, planting bareheaded.

STAIN REMOVAL

3.1

There is an entire canon of stain removal literature, and an arsenal of products to achieve its ends. A woman I went to school with confided her mother's foolproof method for removing red wine stains, which involved white vinegar, baking soda, and seltzer poured from a height of six feet. I have taught myself to take ink out of cotton with acetone, and lipstick from the brim of a hat with dish soap. Of late I have grown fond of spot cleaning with a product that comes as a fluid in a translucent blue plastic bottle, or as a spherical powder in a pail of the sort a child might take to the beach. I rained the powder on the stained edge of a comforter cover and left it to soak for days. When I returned to wash it, the remover had eaten through—or perhaps simply removed —the fabric, leaving a gaping bite.

3.2

My initiation into womanhood was a lesson in the hand-washing of underwear. I had long eagerly anticipated the arrival of menstruation, but left out of the girl power dialectic was how messy it would be. My mother draped my underwear crotch-up across her palm and rubbed the stained part with a dried-out bar of white soap. She pushed her fingers up from underneath and rubbed the fabric against itself until the rust color transferred to the foam. Then she submerged the underwear in the full stoppered sink basin to rinse, and when it rose, began again.

3.3

When my aunt visits, she takes inventory of my mother's linen closets, which are archival and many, set into our upstairs hallway. One summer she stood an ironing board in the kitchen and set about unfolding and reironing all of the sheets and towels and pillowcases and tablecloths. Of the last we had a multitude, some of lace, derived from the various disappearing matriarchs of my line. Watching my aunt hiss her iron, I remembered what my mother told me when I was a child: lace was invented to imitate the appearance of pubic hair. I wondered if anyone had ever been explicit in desiring that look spread across a table, under a meal.

3.4

In college I had a brief period of sewing buttons. Fancying myself good at reinforcement, I took to all my coats. Every one lost all of its buttons in the following months. When moths eat my sweaters, I take them to a reweaver, a woman in a headband magnifier who remarries fibers in the back of a dry cleaner's.

3.5

At my wedding, in accord with Danish custom, my husband was hoisted in the air in the arms of the male guests, who cut his tie and the toes of his socks with scissors. My purpose was to repair his effects and prove my wifely worthiness, which I did not.

3.6

My aunt irons tablecloths that belonged to my great-grandmother, who was born in the century before last. These two women encounter each other through the iron, which I don't even know how to use. To straighten wrinkles I hang the dress in the bathroom while I take a shower, let it figure itself out.

MIDDY

4.1

An unworn piece of clothing is a paradox: in flux, yet static. Faced with the polka-dot blouse, I imagine the missing torso that will fill it, or has already. Outside it is clearly springtime, the season for this vestment. The polka-dot blouse is an almost perfect square, standardized to skim the body's lines.

4.2

One spring I found a green silk shirt that had belonged to a younger version of my mother, a fine collared button-down with a flower embroidered on the breast pocket in emerald thread. I wore it proudly through the end of sixth grade and the summer after. But my breasts continued to assert themselves and by fall I could not close my mother's shirt over my chest. I don't think I mourned its loss to her. If I did she would tell me, as she always did, that the problem belonged to the clothes, not my body. I could see no flaw in her beautiful shirt, nor any possible replacement.

4.3

When my body settled into its shape, my mother called me a bombshell, pneumatic, but I wanted to be a straight line. The letter I.

4.4

I stood in my bedroom with my aunt and mother, crying and tugging at a new green blouse. I was eighteen years old. This one was made from a fabric with a shimmery pine thread running through it, and nipped in at the bottom hem. In the store it had seemed reasonable, if expensive: the closest I was going to get to my mother's shirt. But now, in my bedroom, it wouldn't hang right. As before, the problem was my flesh. My breasts and the swell of my hips bunched it oddly, leaving me miles from the neat hang the store's mirrors had tricked me into seeing.

4.5

"Maybe you should leave it open, over a camisole." My aunt moved to rearrange me. "That's not how it's supposed to be!" I said.

4.6

Nearly 30, I found another green silk blouse, cut deep in front and wide. Strips of the same fabric secure its sleeves, which button to the mid-forearm. Its hem is asymmetrical, longer in the back than in the front. When I first purchased the blouse, my breasts and hips were still a problem, necessitating constant adjustment. But then stress began suppressing my appetite and everything receded. I was so glad to disappear.

GREAT CAKE

5.1

In 1797 Martha Washington ordered the slaves at Mount Vernon to bake a Great Cake in celebration of her husband George's return home from Washington. Mrs. Washington's recipe required "a peck of flour, three quarters of a pound of sugar, three pounds of melted butter, and seven pounds of currants." A later version, recorded by her granddaughter, stipulates "forty eggs worked into four pounds of butter, four pounds of sugar, five pounds of flour, and an equal quantity of fruit."

5.2

The proportions of the Great Cake recipe do not faze me. James Beard's *American Cookery* was my mother's primary cookbook, and Beard thinks nothing of asking one to combine 1 cup butter, 2 cups sugar, 1 teaspoon vanilla, 3 ¼ cups sifted all-purpose flour, 3 ½ teaspoons double-acting baking powder, 1 teaspoon salt, 1 cup milk, 8 egg whites, 12 egg yolks, 1 ¾ (more) cups sugar, ¾ cup (more) butter, and ½ cup rye or bourbon whiskey to produce a Glenna McGinnis Lane cake.

5.3

When I was a child, my mother made four mains: chicken breasts, salmon, steaks, and meat loaf, all baked in the oven in a special pan. She poured olive oil over, and salt and pepper, although the salmon was dotted with butter instead of drizzled with oil. I remember it rich, with a white creaminess I pulled apart with my fork. There were Parker House dinner rolls and, for dessert, chocolate ice cream topped with cereal.

5.4

We ate dinner always in winter, it seems now. In the white world outside the windows I wore bright coats and lost stretchy gloves with stippled palm grips. Around the time I was eleven I announced that I didn't like salmon and hated chicken bones. Steak was boring, and meat loaf was weird. And my mother ceased to cook.

5.5

By the time I began high school, the kitchen trash can was always full of styrofoam. We lived in take-out wonderland. The cabinets held tea bags, dried pasta, cans of soup for sick days. I saw only a bag of frozen peas in the freezer and understood what I had done. With my mother's James Beard, I began churning out cookies and cakes like someone was paying me. I sent them to a faraway boyfriend twice weekly. I took them to school in Tupperware and gave them away.

5.6

Each year in Laredo, Texas, the Society of Martha Washington presents debutantes from prominent families in antebellum dresses piped with delirious floral beading, as it has since 1898. Weighing more than 80 pounds and costing in the neighborhood of 30 thousand dollars, the debutantes' gowns are as impractical a feminine effect as any Great Cake. As with all confections, their meaning lies in their making. The product is a foregone conclusion.

SIREN

6.1

Samplers were the work of virgins guided by spinsters
and widows.

6.2

One snowy day in her kitchen in Rødkærsbro, Denmark,
Elna Duelund Jensen produced a weathered composition
book of handwritten stories circulated amongst her friends
during and following the Nazi occupation, including the
tale of her engagement to my husband's grandfather.
She and her friends called the book *skumsprøjten,* "white
foam on top of waves."

6.3

The Danish for mermaid, *havfrue,* translates literally to "lady
of the sea." At the end of Hans Christian Andersen's story,
the Little Mermaid sacrifices herself, becoming ocean foam.

6.4

"But doesn't *frue* mean wife?" I asked my husband.

6.5

"Lady, wife—it's the same word," he said.

6.6

Before she becomes foam, the Little Mermaid opens
her mouth and lets the Sea-Witch cut out her tongue in
exchange for feet that walk always on hot knives.

6.7

Post-*skumsprøjten*, Elna's husband purchased a shoe store and told her she would be running it. For diversion, she and a friend have shared a weekly copy of *Familie Journal,* a sort of Danish *Good Housekeeping*, for more than 50 years.

6.8

Since its installation quayside in Copenhagen, Edvard Eriksen's bronze of the Little Mermaid has been smothered in paint, draped in a burqa, and detonated with explosives that left holes in her wrist and knee. Her arm has been sawn off, and she has suffered three decapitation attempts, two successful. The unsuccessful attempt left in her neck a seven-inch-deep wound. A few years ago they sent her to Shanghai for five months to mourn prettily at an Expo. There is a Chinese story of a mermaid who weeps pearls.

6.9

The girl's hair is the same yellow as the leaf-edges adorning her corner. The neckline of the woman's shirt inverts the rise of the back of her chair. My husband's grandfather died before he was born and today Elna sleeps in a twin bed in her kitchen and washes in a bathroom hung with ageless effects: a gold key on a chain, a white plastic comb, a letter opener shaped like a dagger. In an attempt to free her, the Little Mermaid's sisters trade their hair for a knife that can return the Mermaid to the sea. But the Little Mermaid surrenders her consciousness instead of killing the prince, because femininity is a horror story.

CHAMBERS

7.1

"There is no final solution" for objects, Joan Didion wrote, "nor is there any answer." And yet they persist, sorted and prettily arranged and impossible. Postcards affixed to the wall near the window. A map on the back of the door. A frame named EDITH E. An Oriental rug beneath a bent leg, a foot. The dress suspended on its paper-wrapped hanger from a wall-mounted light fixture meant to evoke an oil lamp that was undoubtedly once an oil lamp.

7.2

Some time ago now I began clearing the house whenever I came home to visit, and discovered that in nearly 30 years my parents had not thrown away anything other than literal trash. All of it was still there, packed into cabinet and shelf and drawer and stacked in towers in the basement, paralyzing me.

7.3

"These small bits of embroidered cloth are often all that remains to testify to the otherwise unrecorded lives of their makers," the Metropolitan Museum of Art's Amelia Peck writes of samplers.

7.4

My parents' bathroom has peach walls and beige carpet and jack-and-jill sinks, and my mother has clustered around hers bobby pins and makeup brushes in crystal tumblers and shotglasses. So constant were her long amber pins, and strong. But my mother never pins up her hair. Her drawers are populated with long-discontinued Chanel cosmetics and their huff of ambergris and hue. My mother applied blush to my cheeks with a great fluffy brush and told me to close my eyes. She held her hand over my face, coated my hair in spray, and cried, "Go!" She had taught me to run immediately out of the bathroom when the can's hissing ended, so that I would not breathe poison.

7.5

Out of the bathroom and into the little hall antechamber where my parents' many closets dwell. One holds back-stores of toothpaste, French milled soap, dental floss, and an abundance of toothbrushes. Another only ties, a third my mother's carefully hung cotton nightgowns. The one just beside the window beneath which my mother has placed the bench on which her grandfather prayed every morning of his 99 years holds her perhaps fifteen pairs of size-seven medium heels. They must have been important when they moved into the house, but I have never seen my mother in any, least of all the lace-detailed pair that moans bridal.

7.6

In the bathroom, she got ready to go out to dinner with my father, brightening her cheeks and closing her eyes and holding one hand over her face while the other sprayed her hair. After, she went downstairs and put on one of her fur coats. At eleven they came home I pushed my face into her cold fur, smelling smoke. There was always more: more blush, more hairspray, more coats, more unworn shoes. I didn't even have to open the closet.

7.7

In fairy tales the princess is cast from her castle alone and bereft of belongings. If she survives her trial she will reclaim her treasure. After I left home I lived first in a dormitory, where I often marked a young woman waiting by the elevator banks. Her hair morphed from yellow to brown and back again and she seemed always to me to be a perfect beauty. I wrote a story of her, or perhaps I merely wrote her into my own.

7.8

Tonight we stake the tent in the eastern clearing, she and I, and draw a map in the candlelight reflected in the mirror. We have never lost a single thing. It all waits still. Revision, reorganization, reshelving. The shoes on their racks, the jewels in their zipper pockets, the space inside the empty blouse. There is a fantasy of escape from these things, a romance of loss that lives at odds with the proof. The faces captured in frames. The moving boxes stacked beneath. The silver dish tilting to the camera's eye. A mended tear cast again into light, smoothed, folded: that rending of the veil.

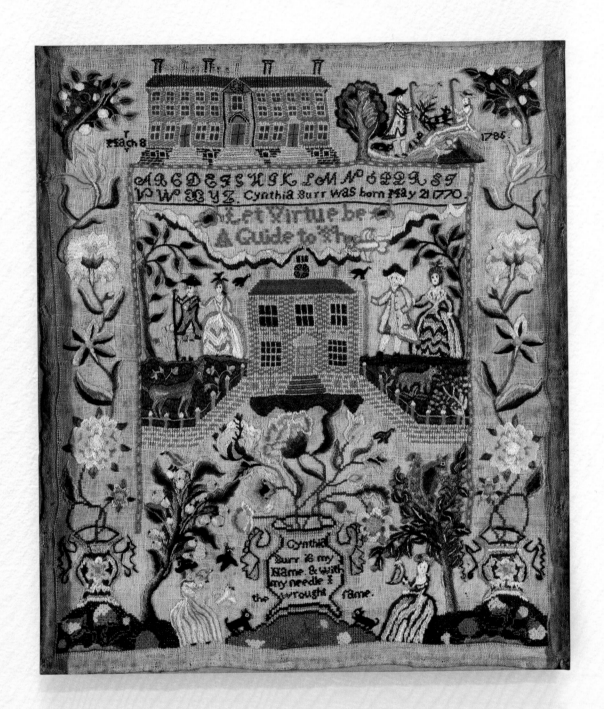

All images from *Let Virtue Be Your Guide* were taken between 2011 and 2014. They were made in nine private residences located in Maine, Massachusetts, New York, and Rhode Island.

Photographs from this series are archival pigment prints in the following sizes:
15 x 15 inches (edition of 5)
11 x 11 inches (edition of 7)

PLATE LIST

p. 5. *Edith, with a portrait of her ancestor* (Milton, MA) 2013

p. 6. *Floral patterns* (Woods Hole, MA) 2013

p. 9. *My mother's hands* (Salem, MA) 2012

p. 13 *Portrait of my grandmother, in my mother's house* (Cambridge, MA) 2012

p. 15. *Candelabra* (Bar Harbor, ME) 2012

p. 16. *Carpet stains* (Bar Harbor, ME) 2012

p. 17. *Hope, in the guest bedroom* (Bar Harbor, ME) 2012

p. 21. *Moving boxes* (Milton, MA) 2013

p. 22. *Aunt N., before her portrait* (New York, NY) 2013

p. 25. *Jewelry* (Milton, MA) 2014

p. 28. *House, through the trees* (Saunderstown, RI) 2011

p. 31. *Lali, Woods Hole* (Woods Hole, MA) 2013

p. 32. *Float* (Northeast Harbor, ME) 2011

p. 33. *My mother, after her swim* (Prettymarsh, ME) 2014

p. 35. *Club girls* (Northeast Harbor, ME) 2011

p. 39. *Polka dot blouse* (Providence, RI) 2014

p. 41. *Attic* (Woods Hole, MA) 2013

p. 42. *Matrilineage* (Cambridge, MA) 2012

p. 45. *Bedroom* (Milton, MA) 2013

p. 47. *Jes, in her ancestor Louisa May Alcott's house* (Concord, MA) 2013

p. 49. *China pantry* (Woods Hole, MA) 2013

p. 50. *Tablecloth* (Milton, MA) 2013

p. 51. *Cake* (Cambridge, MA) 2013

p. 55. *My mother, Thanksgiving* (Cambridge, MA) 2013

p. 56. *Paternal family tree* (Woods Hole, MA) 2013

p. 59. *Martha (great-grandmother)* (Woods Hole, MA) 2013

p. 62. *Storage* (Milton, MA) 2014

p. 65. *Wallpaper* (Brookline, MA) 2012

p. 66. *Edith, with the blue Volvo* (Isle au Haut, ME) 2013

p. 67. *Walk* (Isle au Haut, ME) 2013

p. 71. *Touch* (Isle au Haut, ME) 2013

p. 73. *Hierarchies* (Woods Hole, MA) 2013

p. 74. *Catching up* (Isle au Haut, ME) 2013

p. 77. *Edith, at home* (Milton, MA) 2013

p. 81. *Kitchen walls* (Woods Hole, MA) 2013

p. 83. *My mother, Salem cemetery* (Salem, MA) 2012

ACKNOWLEDGMENTS

With gratitude to my family, most especially to my parents. And to my husband, Joshua Brau.

Thank you to all the women I photographed during the evolution of this project, and to my extended family for contributing their words:

EHE, ESE, HDW , KLW , DM, JCS, NFD, LEW, MBW, GW III, JRR, BKL, MCT, EKT, LKC, KSC, MEC, CTC, ATC, JF, CMF, FF, JPS, DF, LZ, RBD, SPD, GPD III, LWD, HWF, GPD IV, AD, FAE II, PNBE, MBH, CHT, PDT, WCT.

And to:

Steven B. Smith, Ann Fessler, Eva Sutton, Anne West, Jennifer Liese, Lisa Young, Maya Krinsky, Noura Al-Salem, Caitlin FitzGerald, David Chickey, Lisa Locascio, Brian Paul Clamp, Todd Bradway, Thomas Palmer, Aline Smithson, Justin Kimball, the Eustis family, Louisa May Alcott's Orchard House in Concord, Massachusetts, and the RISD Museum.

RADIUS BOOKS
227 E. Palace Ave. Suite W
Santa Fe, NM 87501
t: (505) 983–4068
www.radiusbooks.org

Available through
D.A.P. / DISTRIBUTED ART PUBLISHERS
155 Sixth Ave., 2nd Floor
New York, NY 10013
t: (212) 627–1999
www.artbook.com

ISBN 978-1-842185-00-0

Library of Congress Cataloging-in-Publication Data
available from the publisher upon request.

DESIGN: David Chickey
COPY EDITING & PROOFING: Laura Addison
PRE-PRESS: John Vokoun

Printed by Editoriale Bortolazzi-Stei, Verona, Italy